MANDALA COLORING BOOK FOR ADULTS

THIS BOOK BELONGS TO

Copyright © 2019 by Cathy Rose

All rights reserved. This book or any portion thereof may not be reproduced or used in any manner whatsoever without the express written permission of the publisher except for the use of brief quotations in a book review.

First Printing, 2019

"The flower's perfume has no form, but it pervades space. Likewise, through a spiral of mandalas formless reality is known."

- Saraha

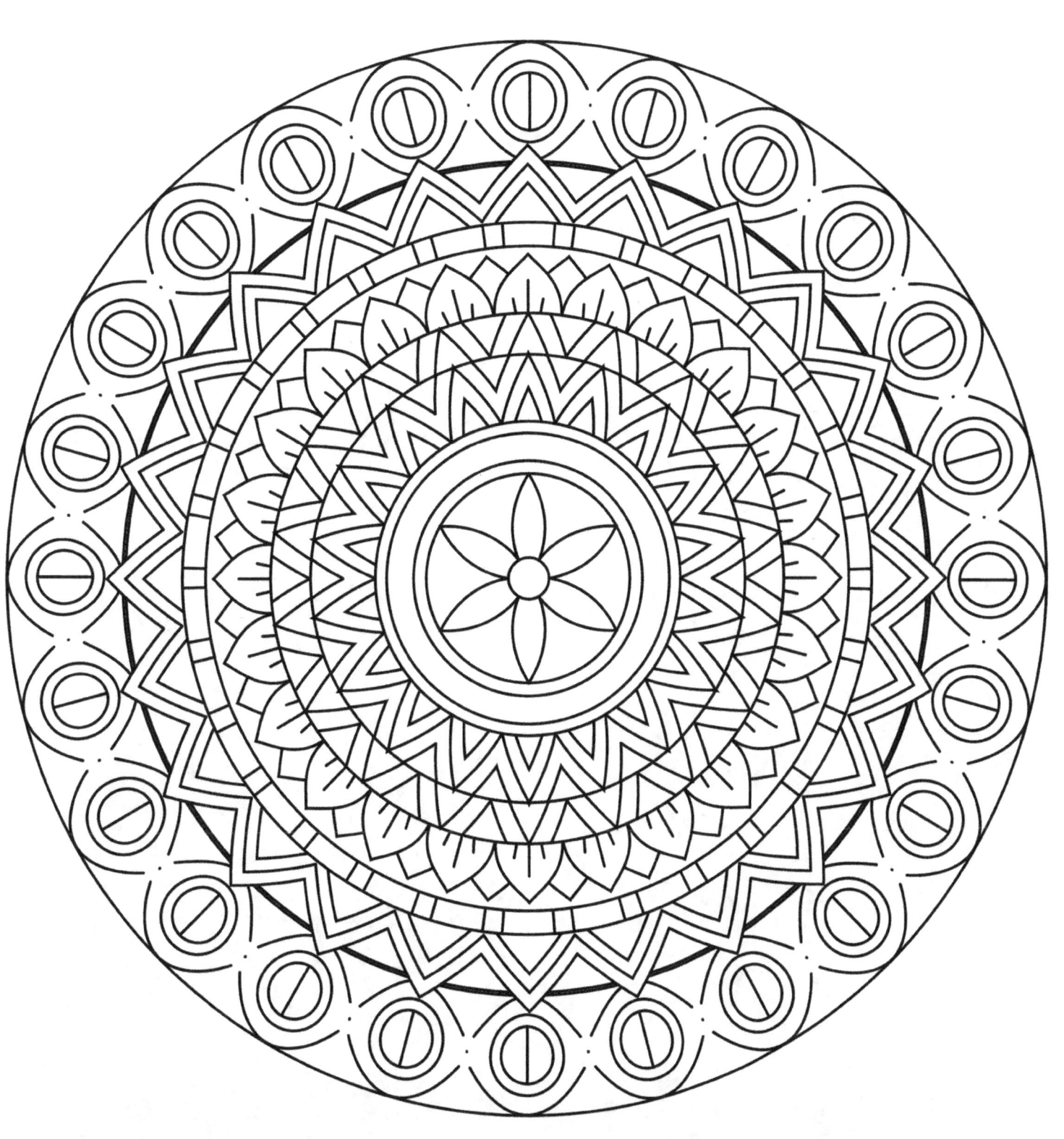

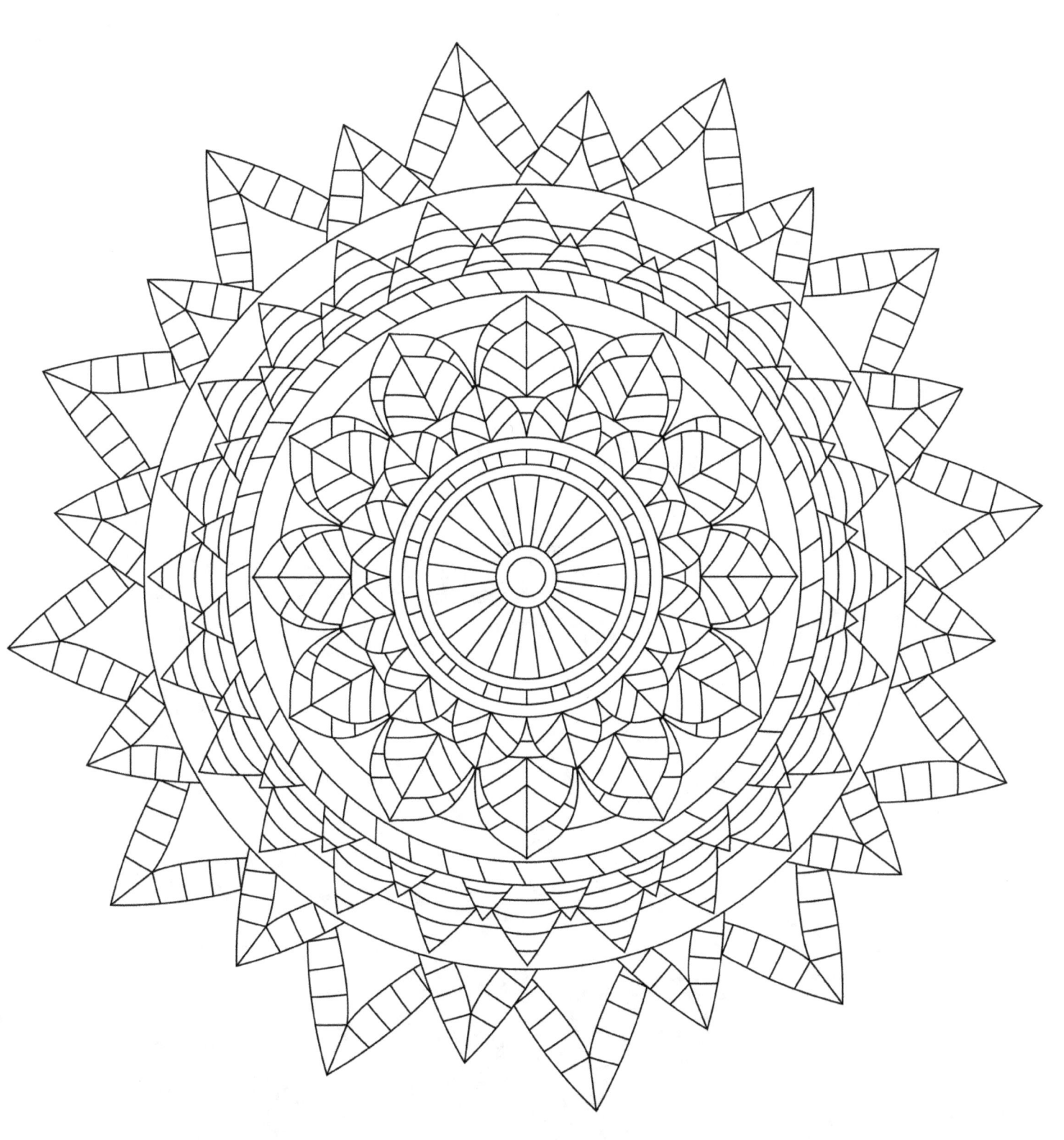

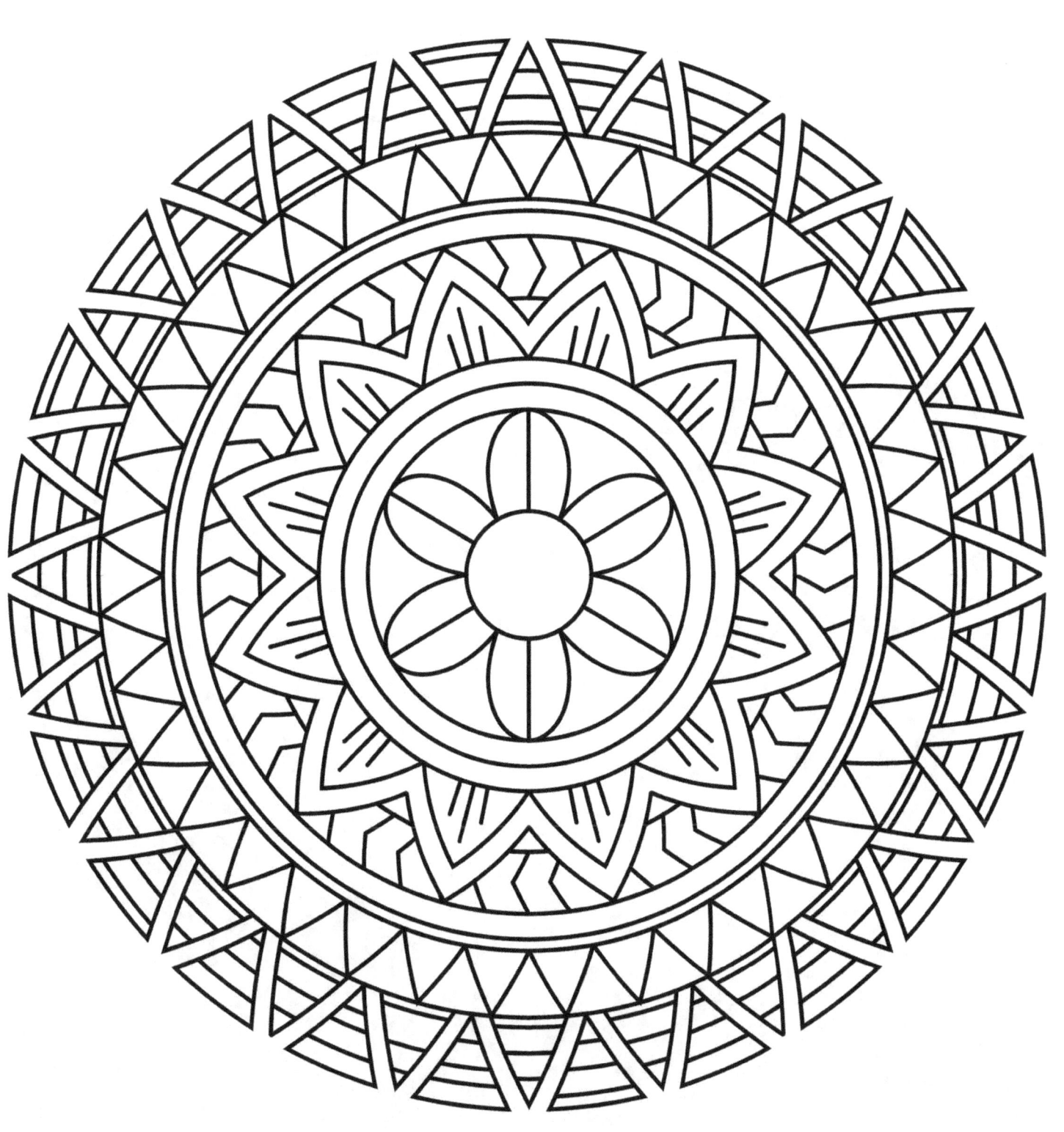

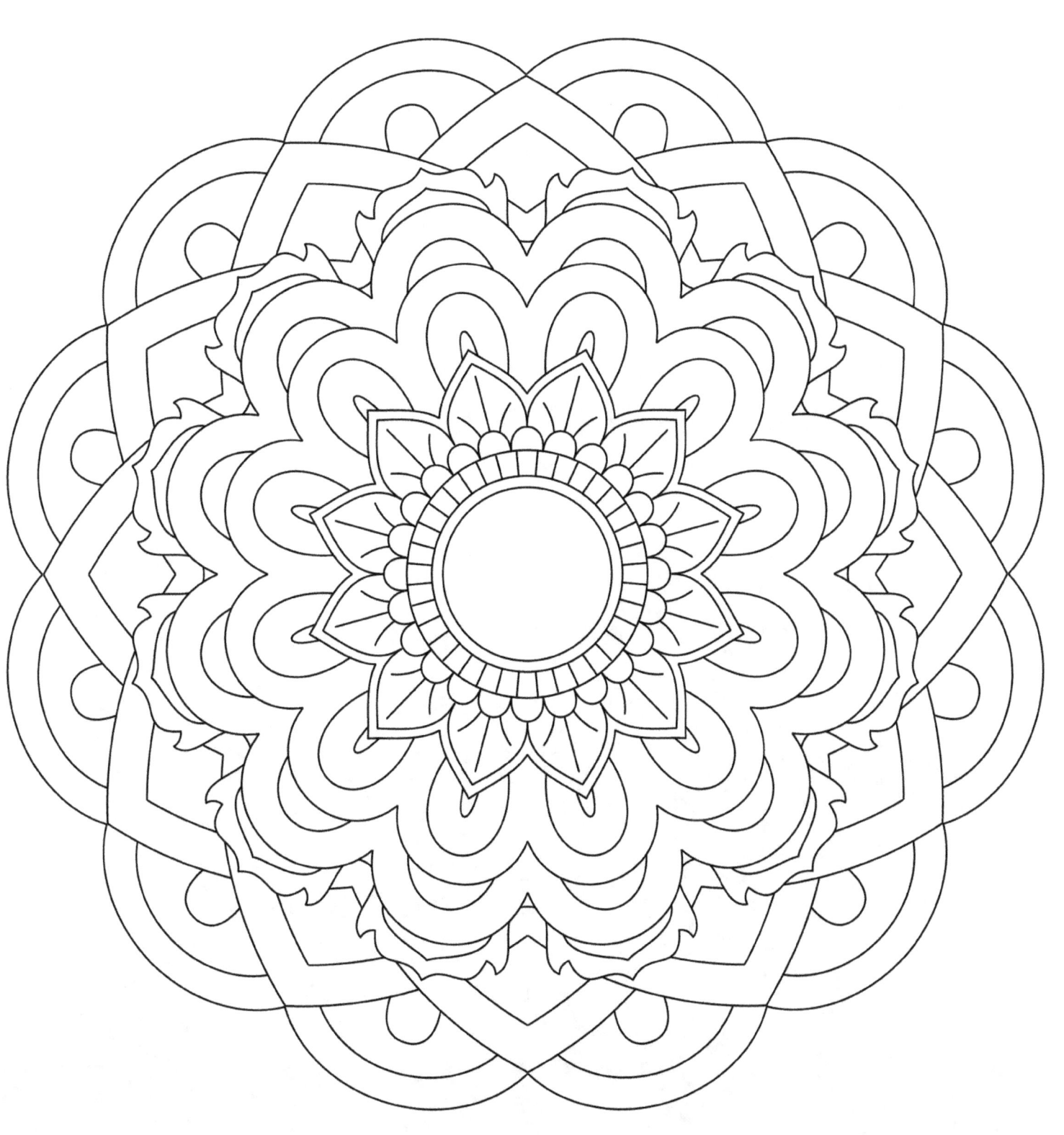

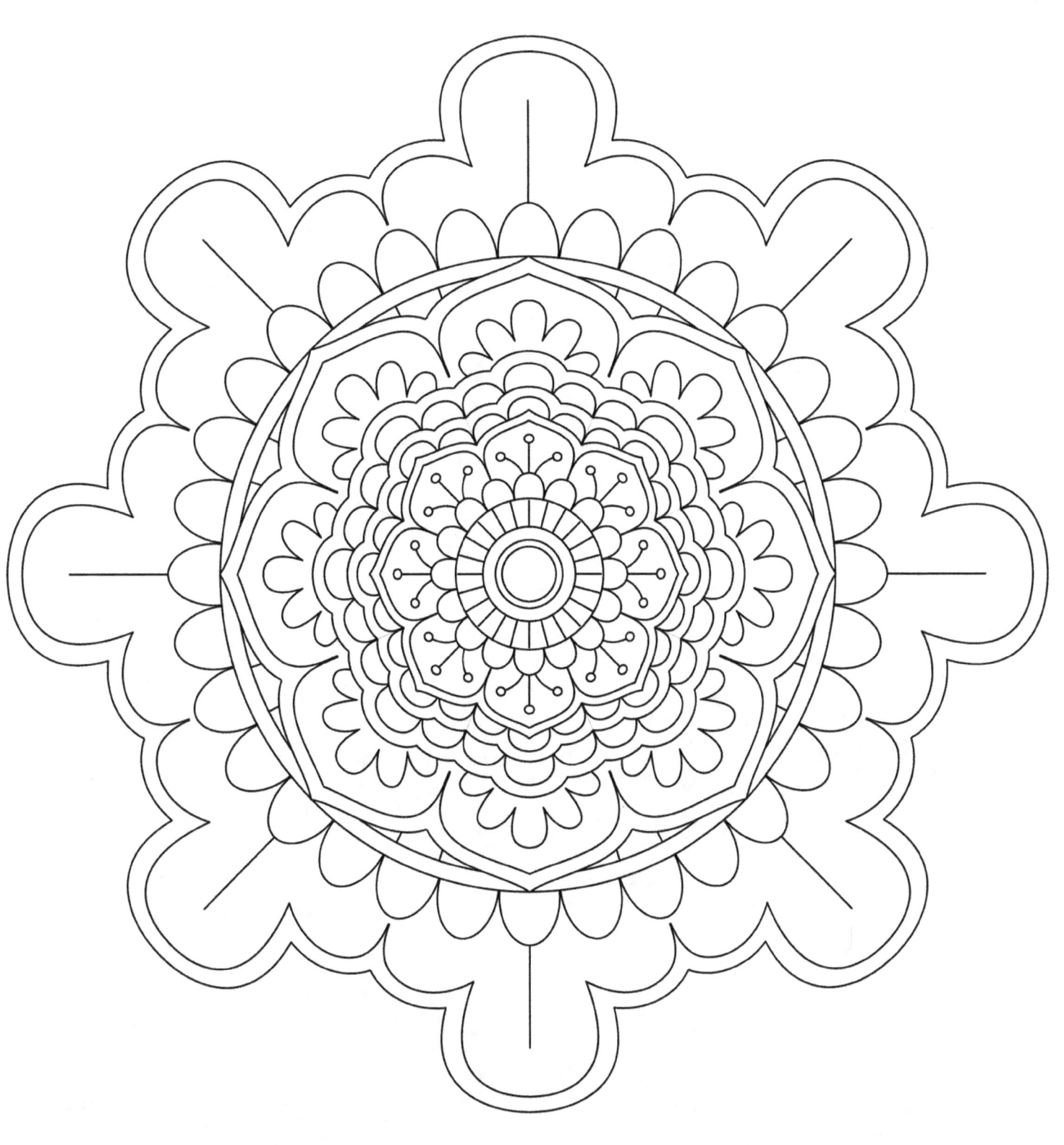

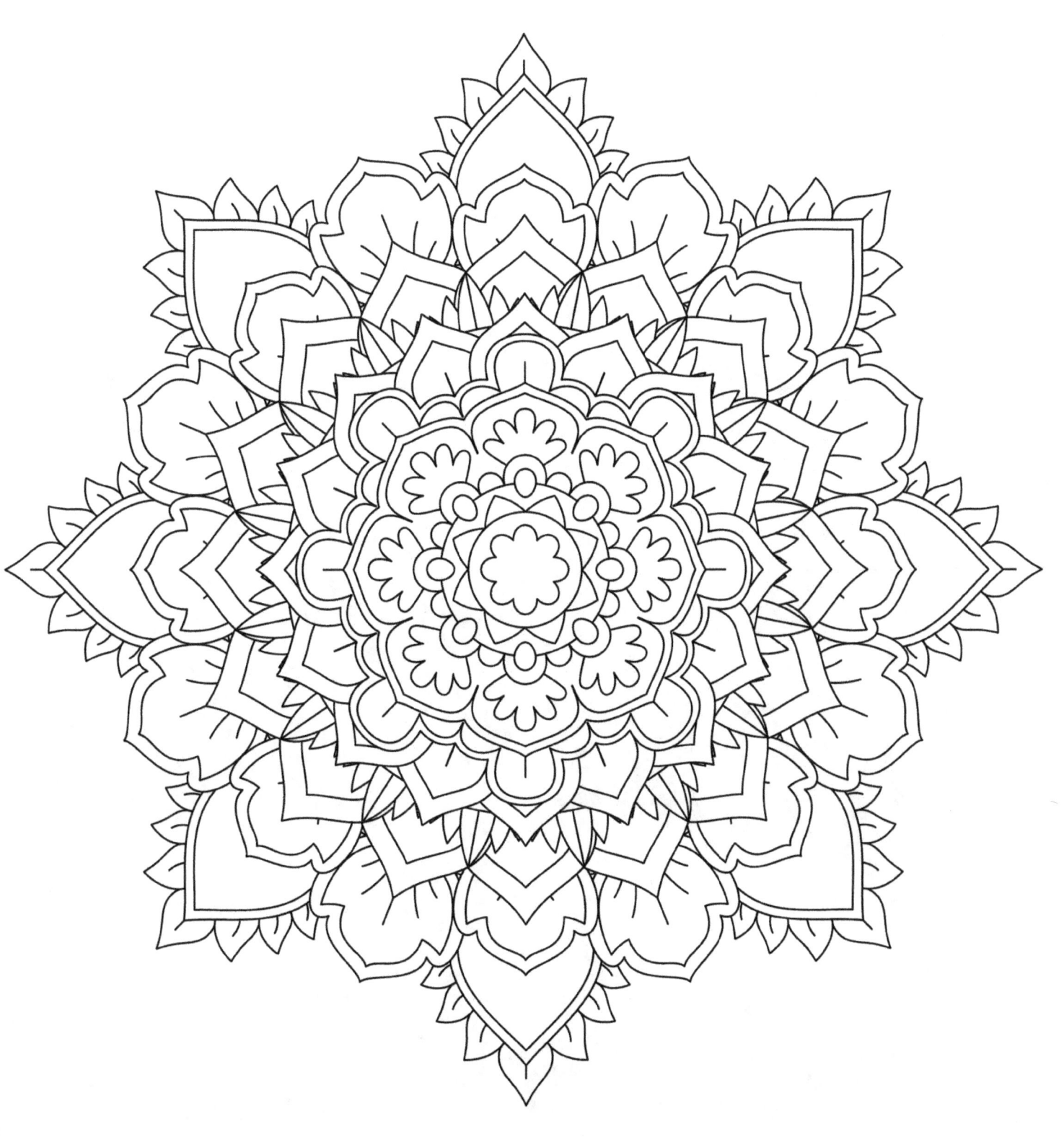

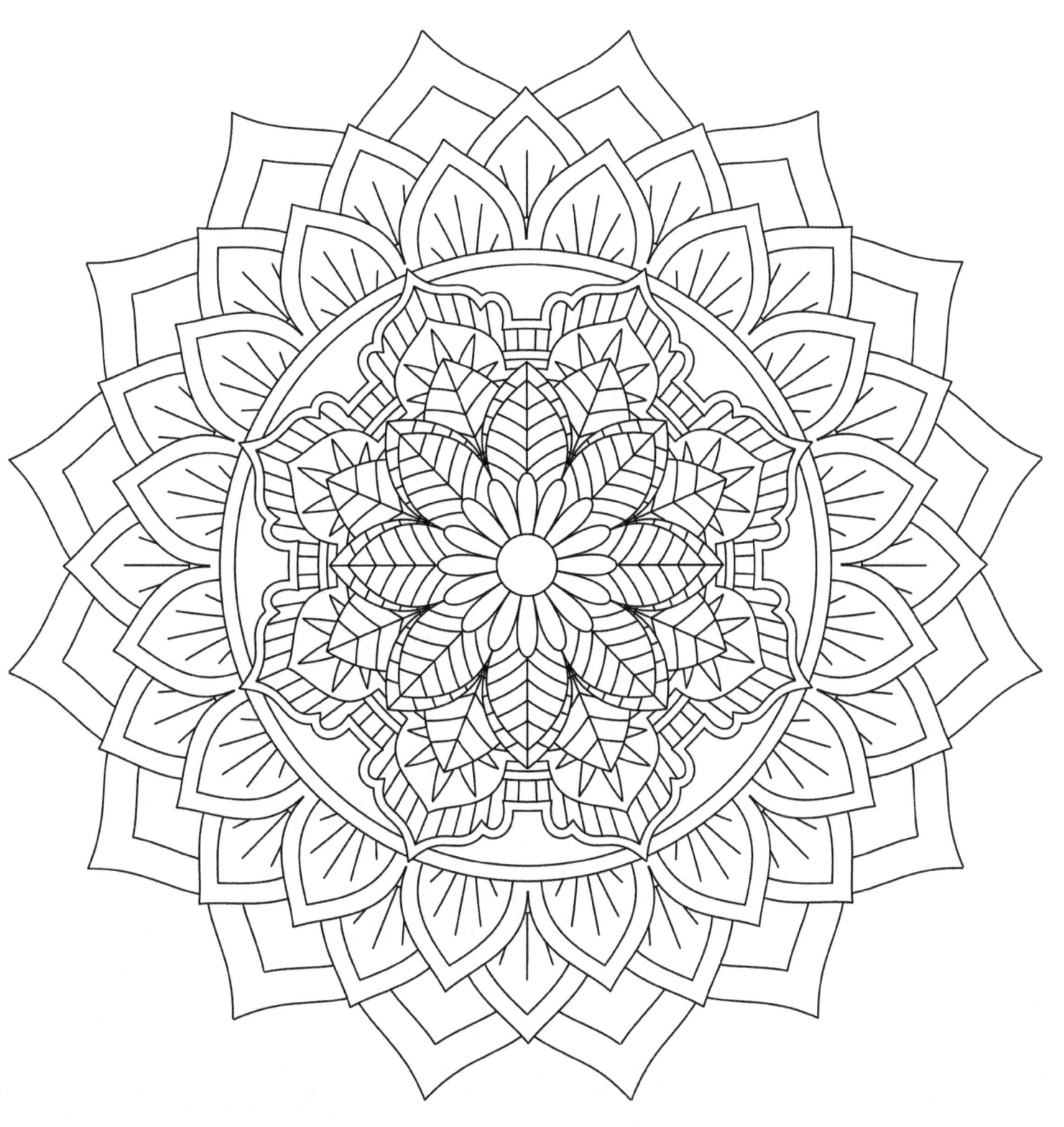

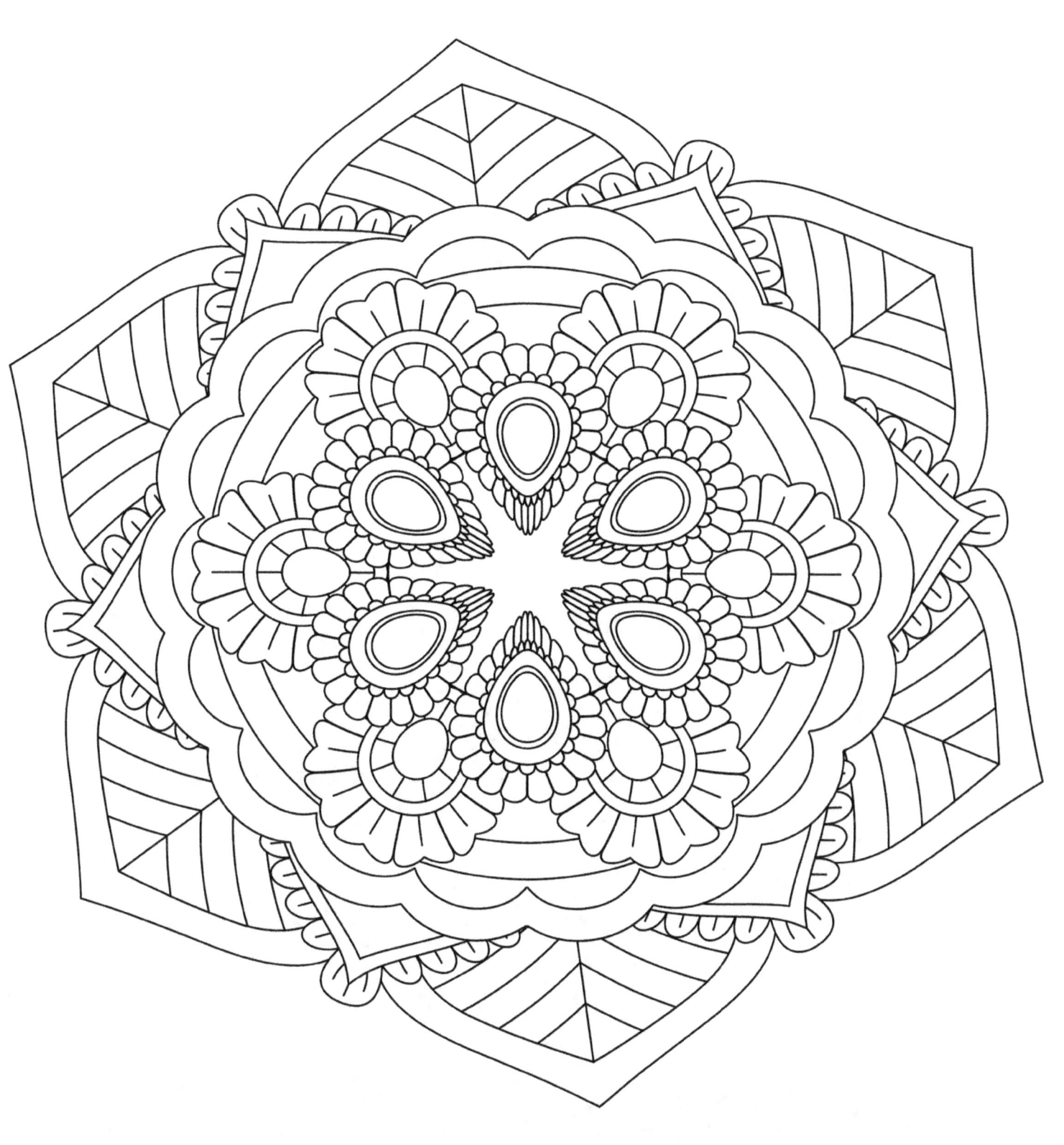

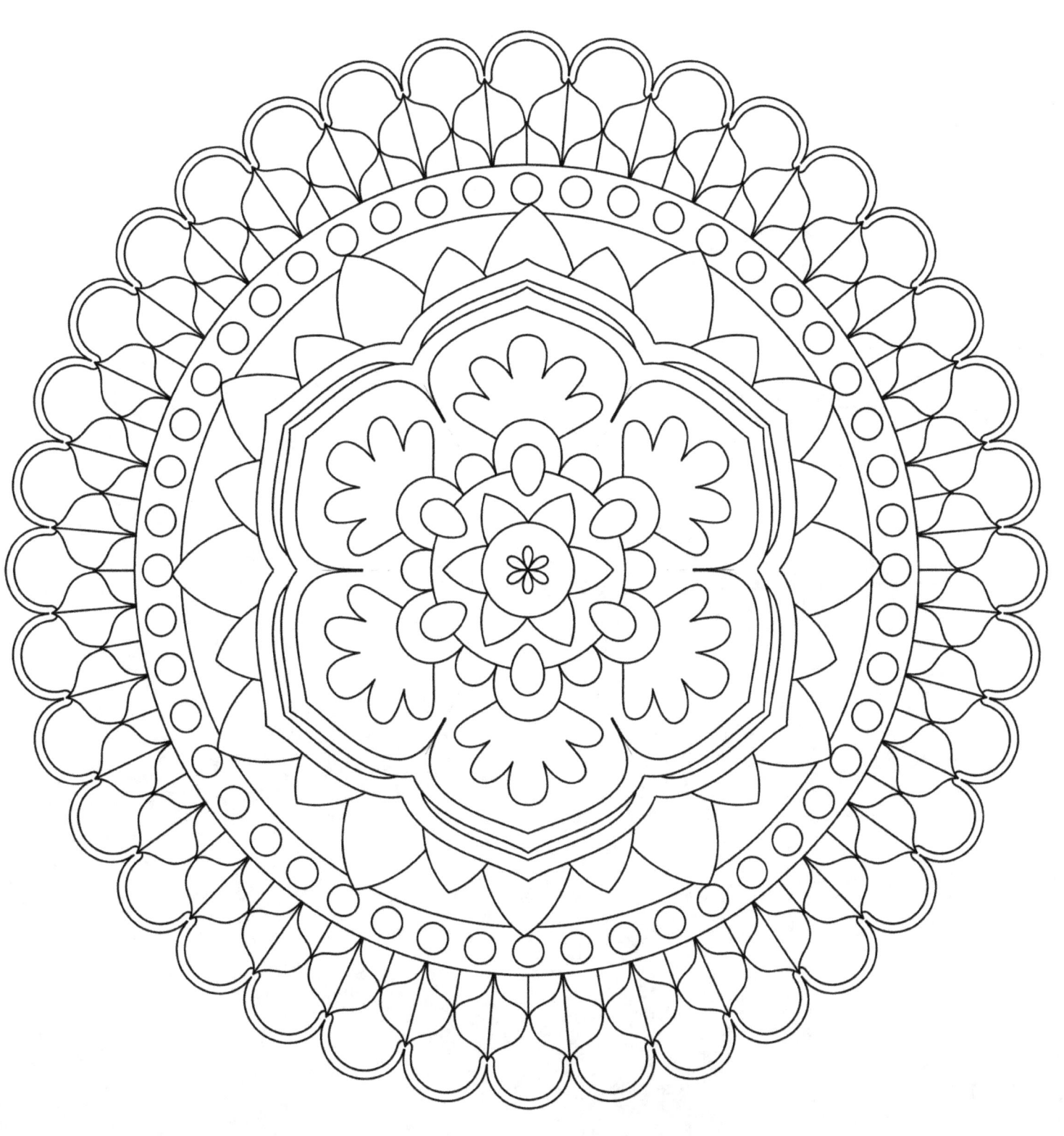

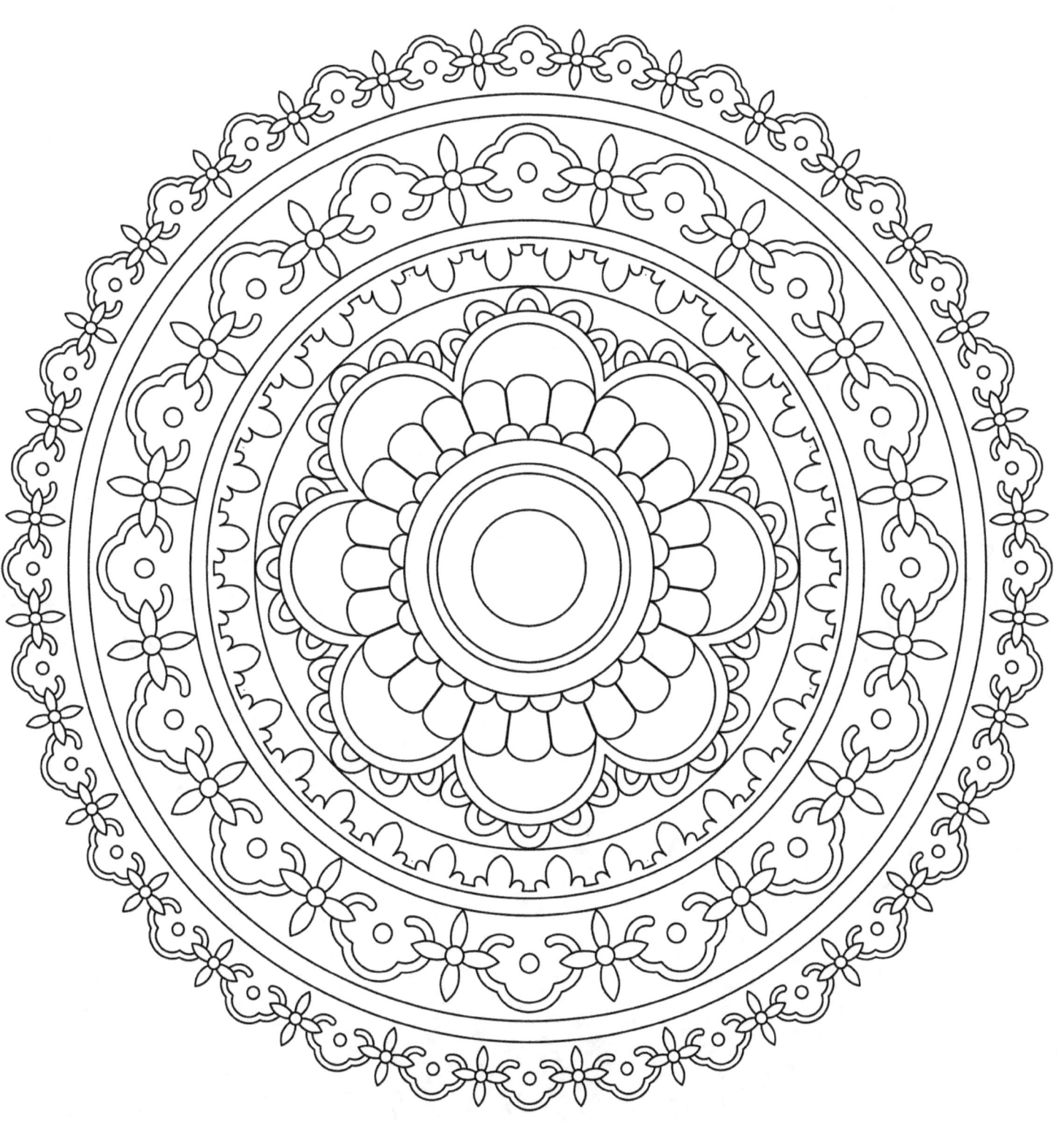

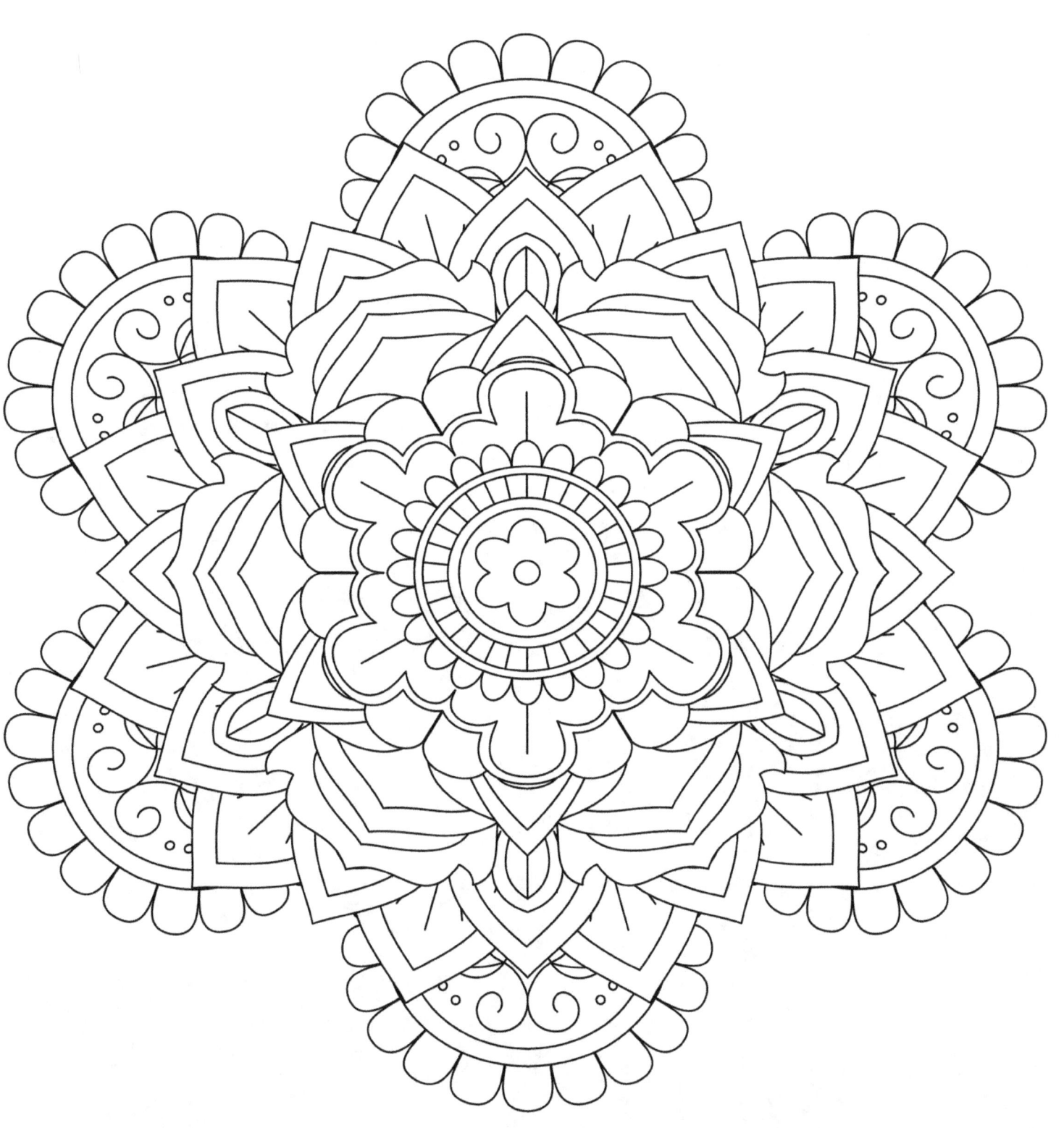

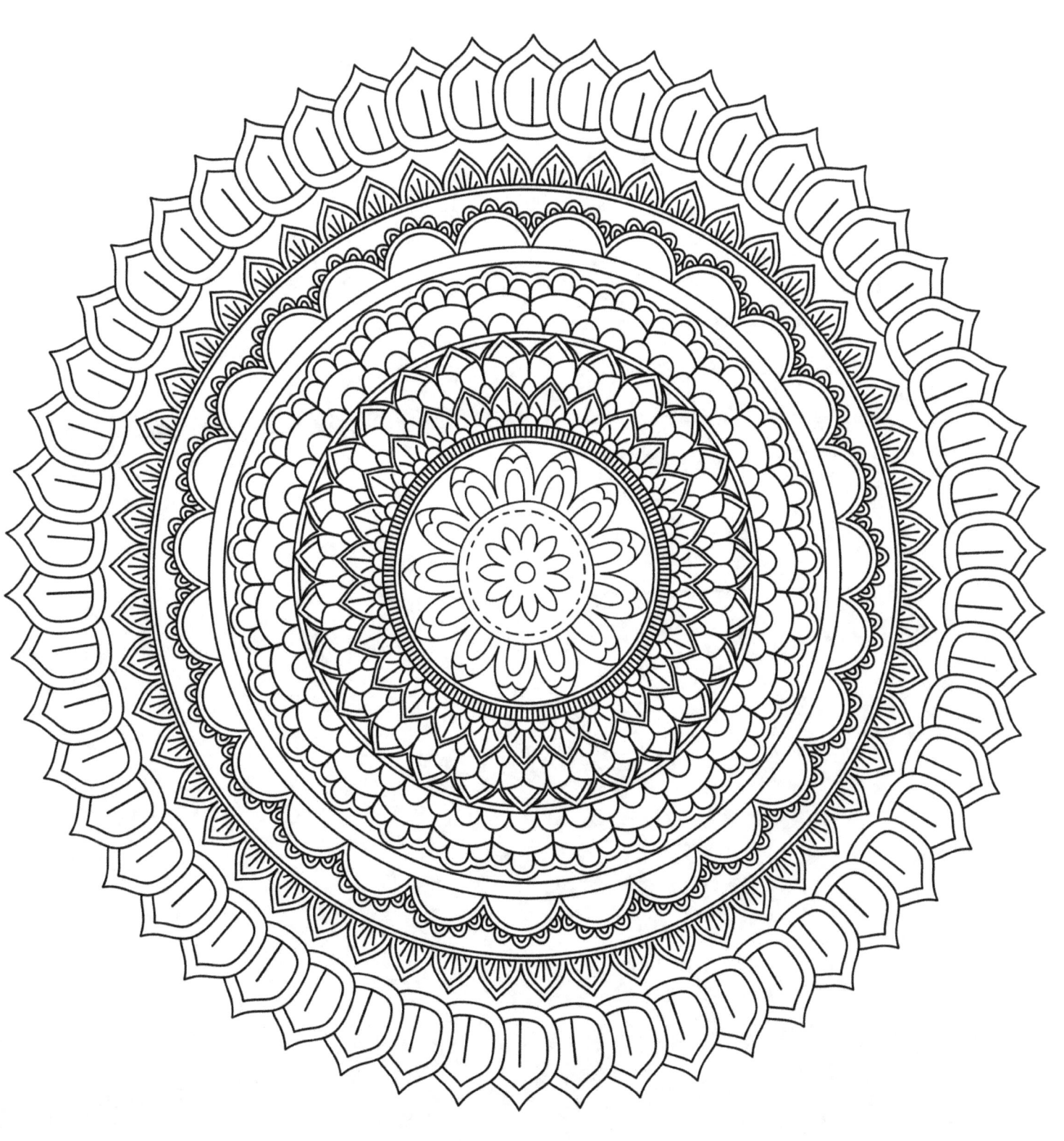

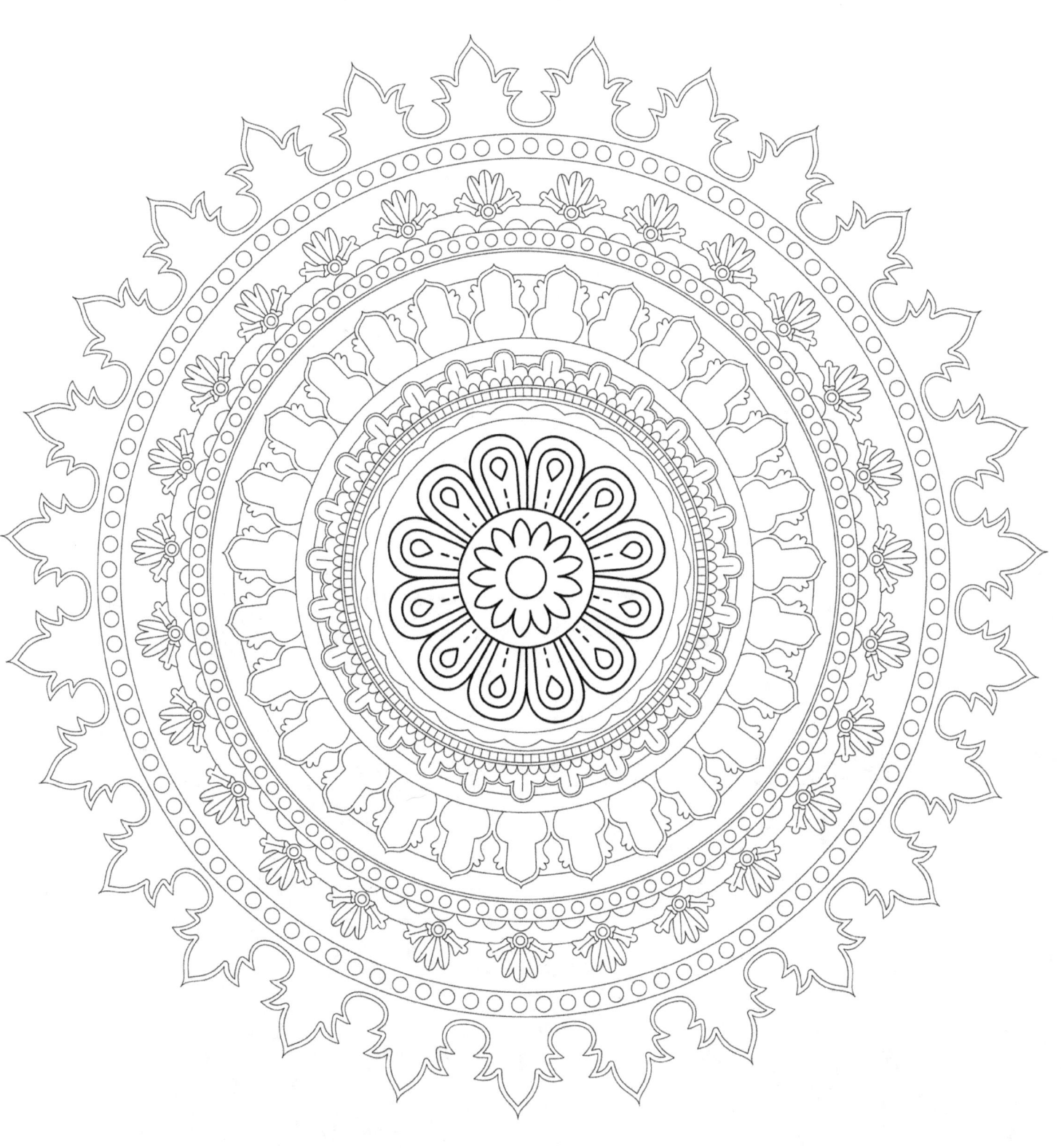

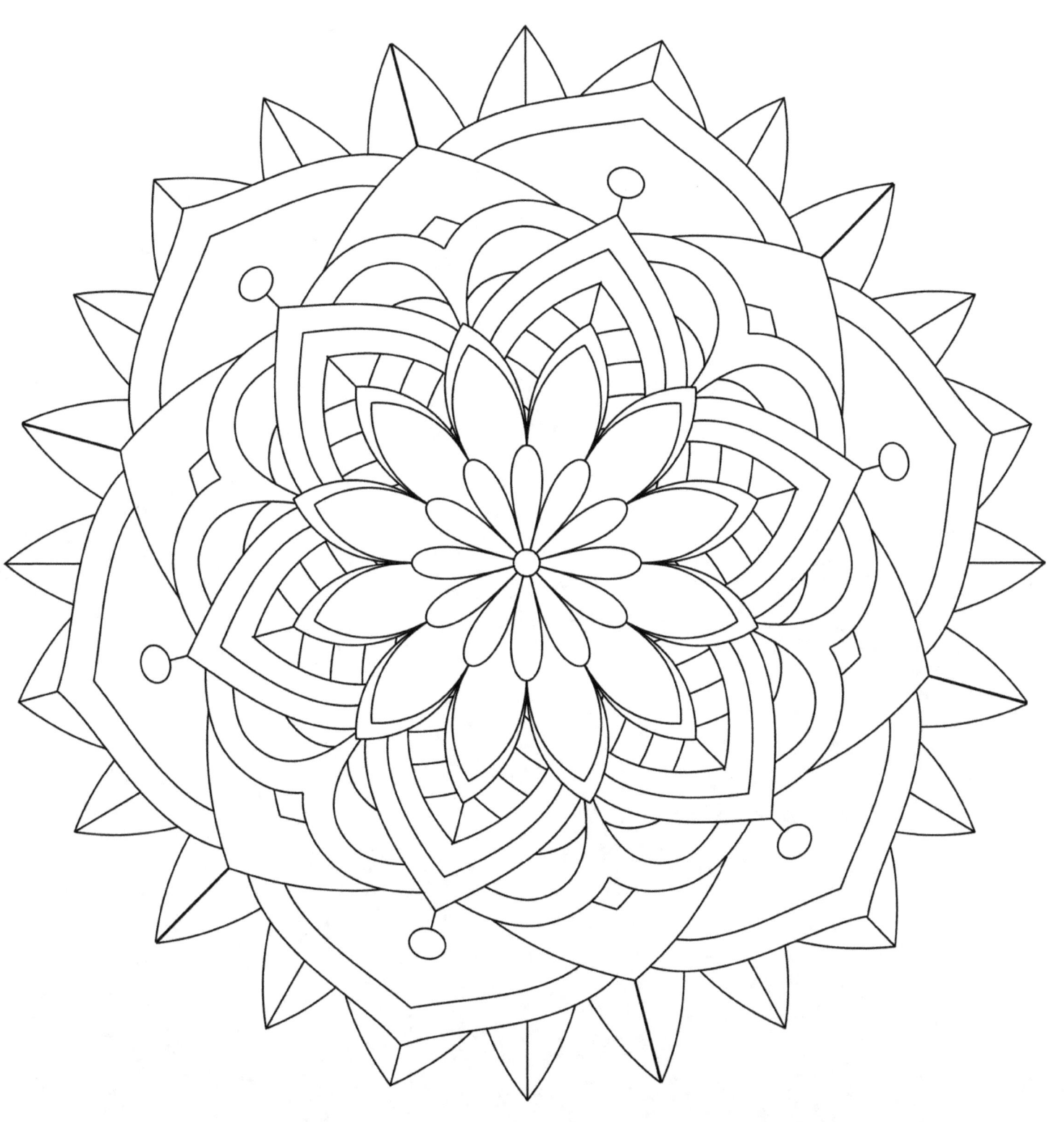

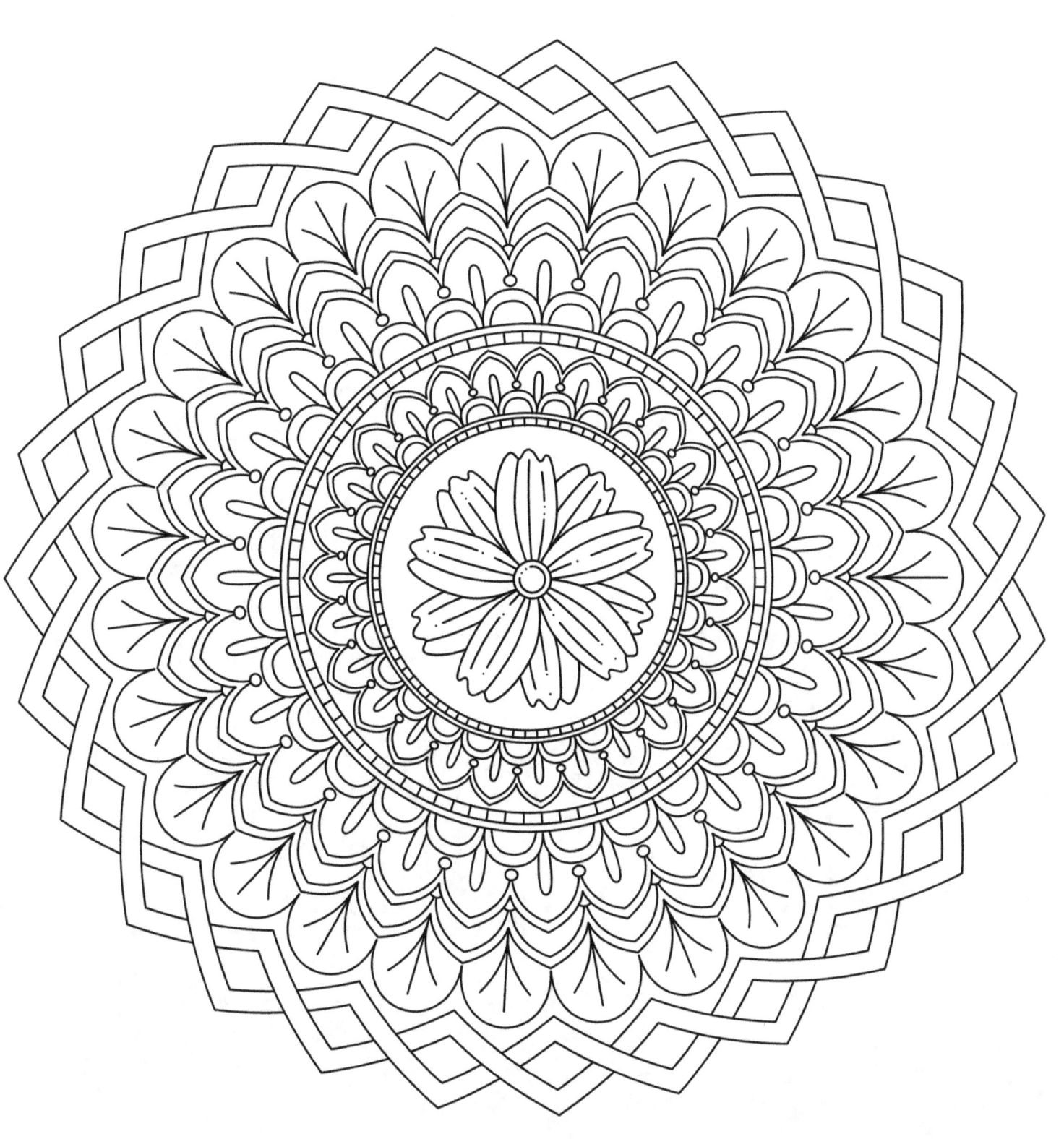

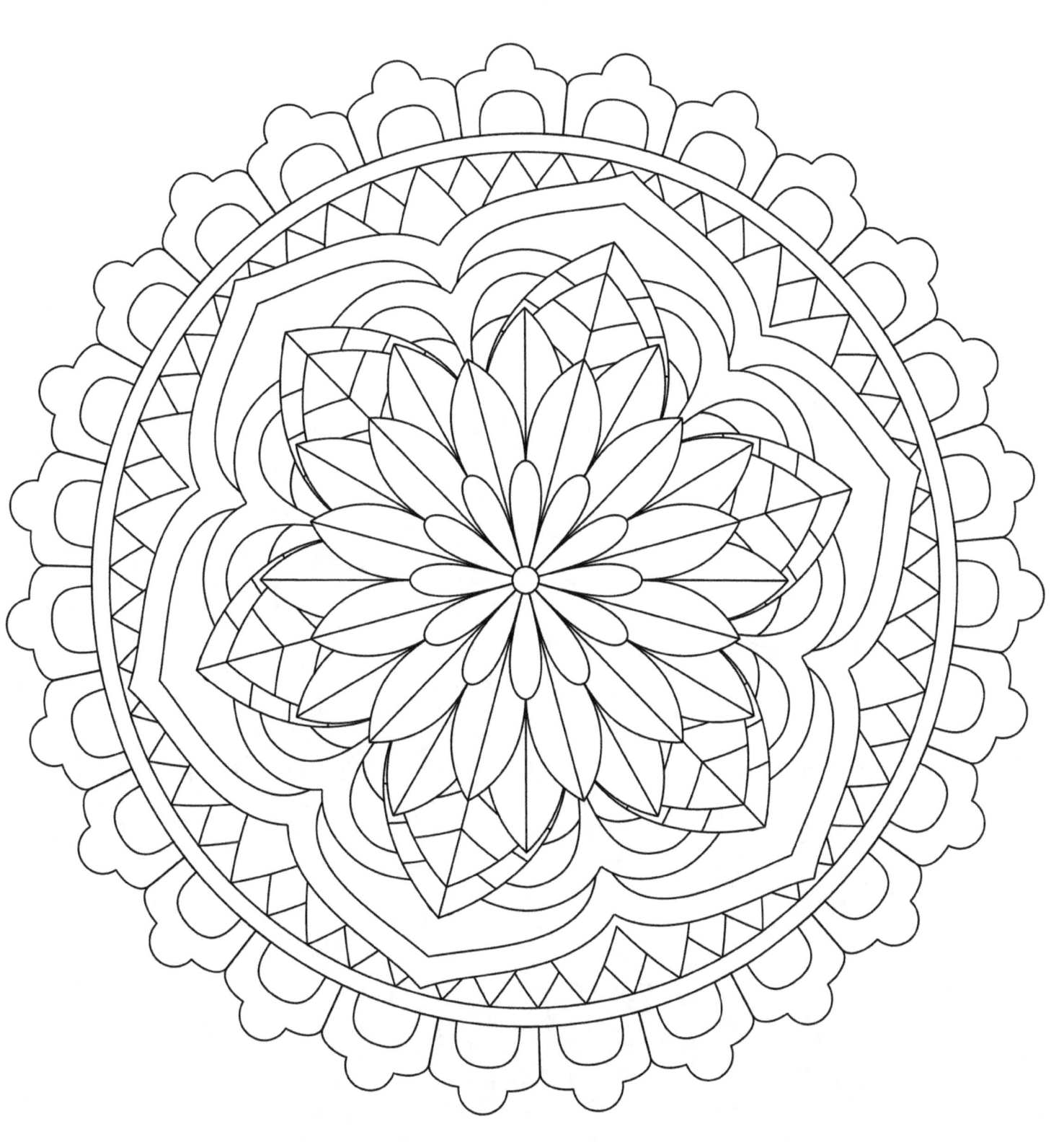

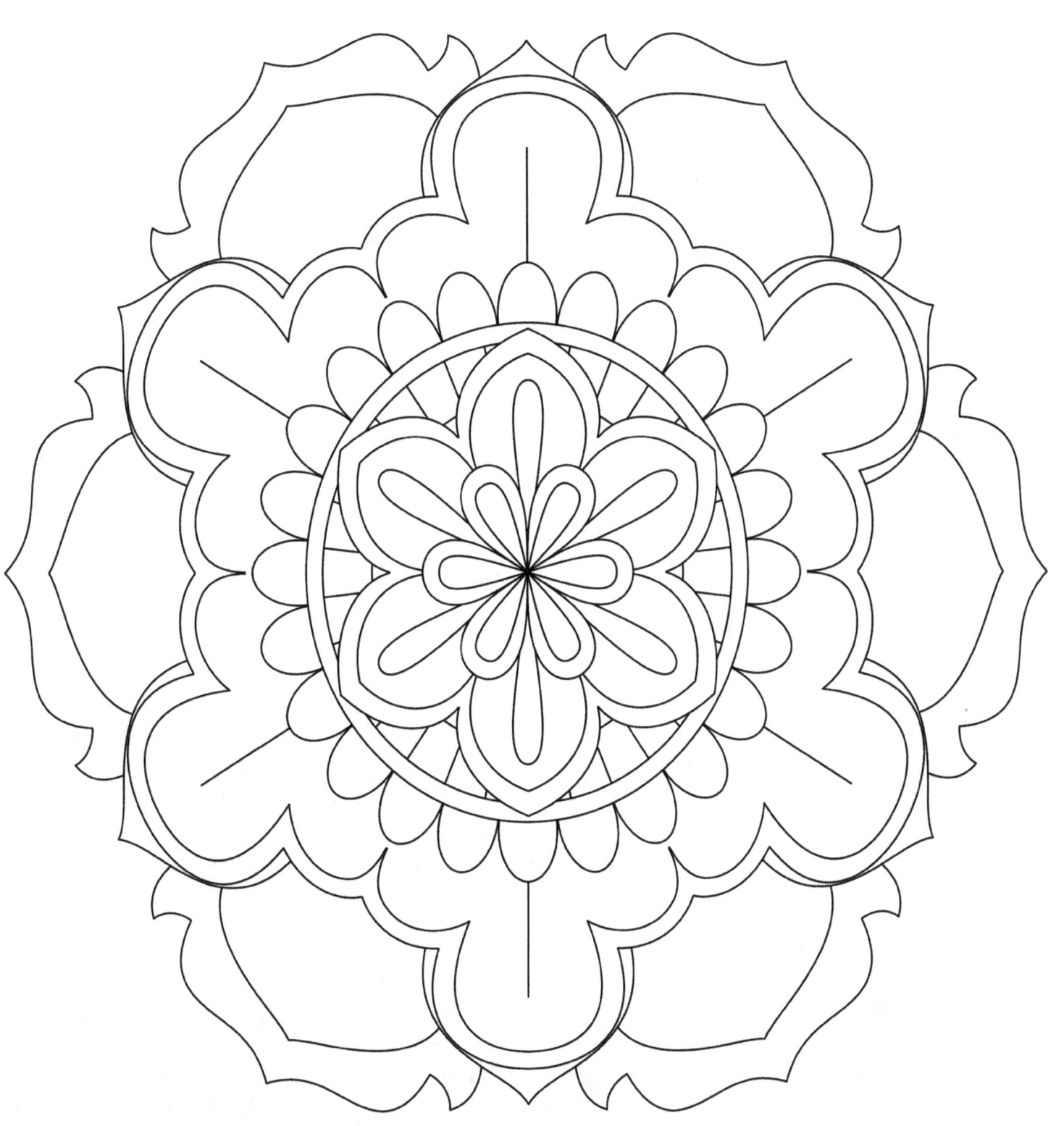

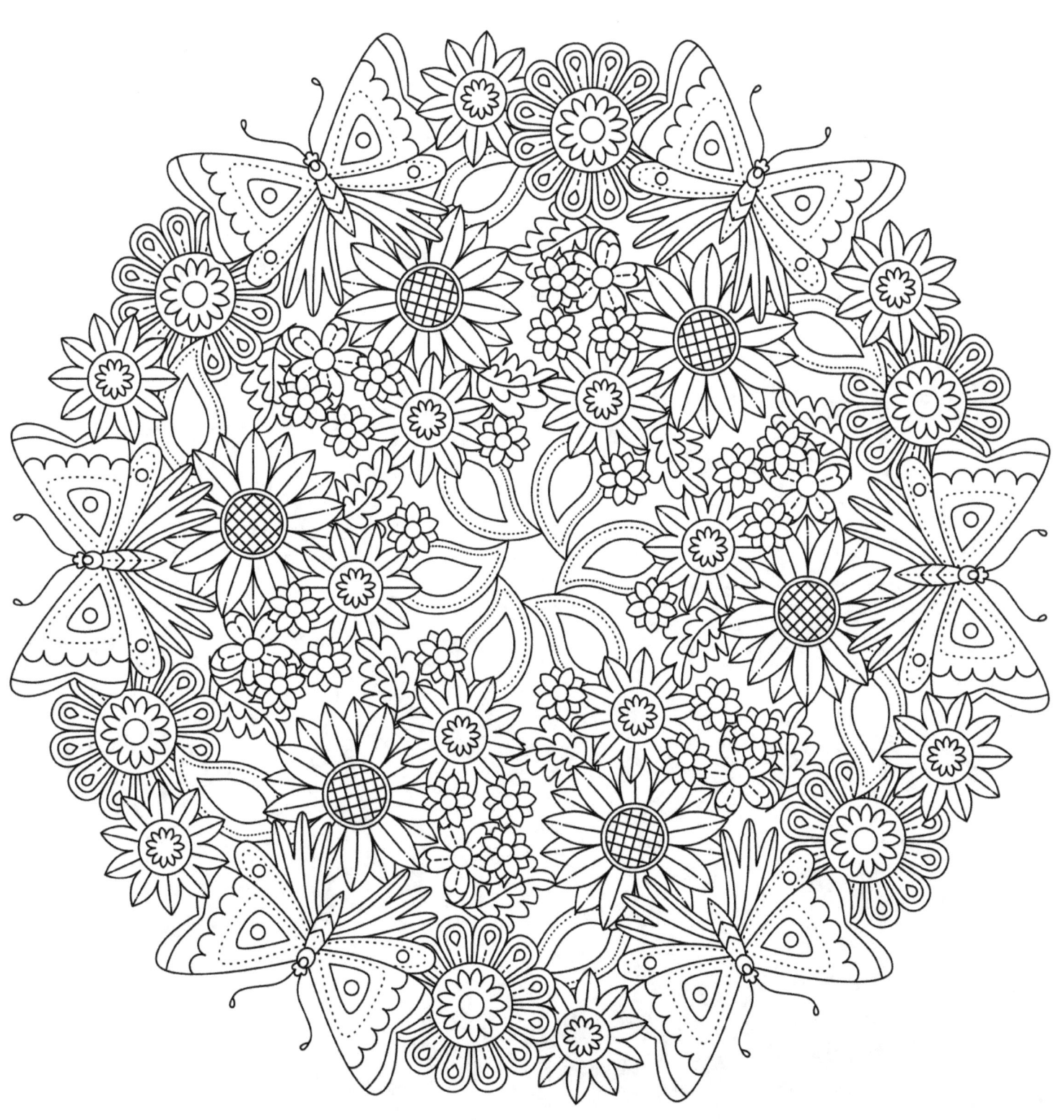

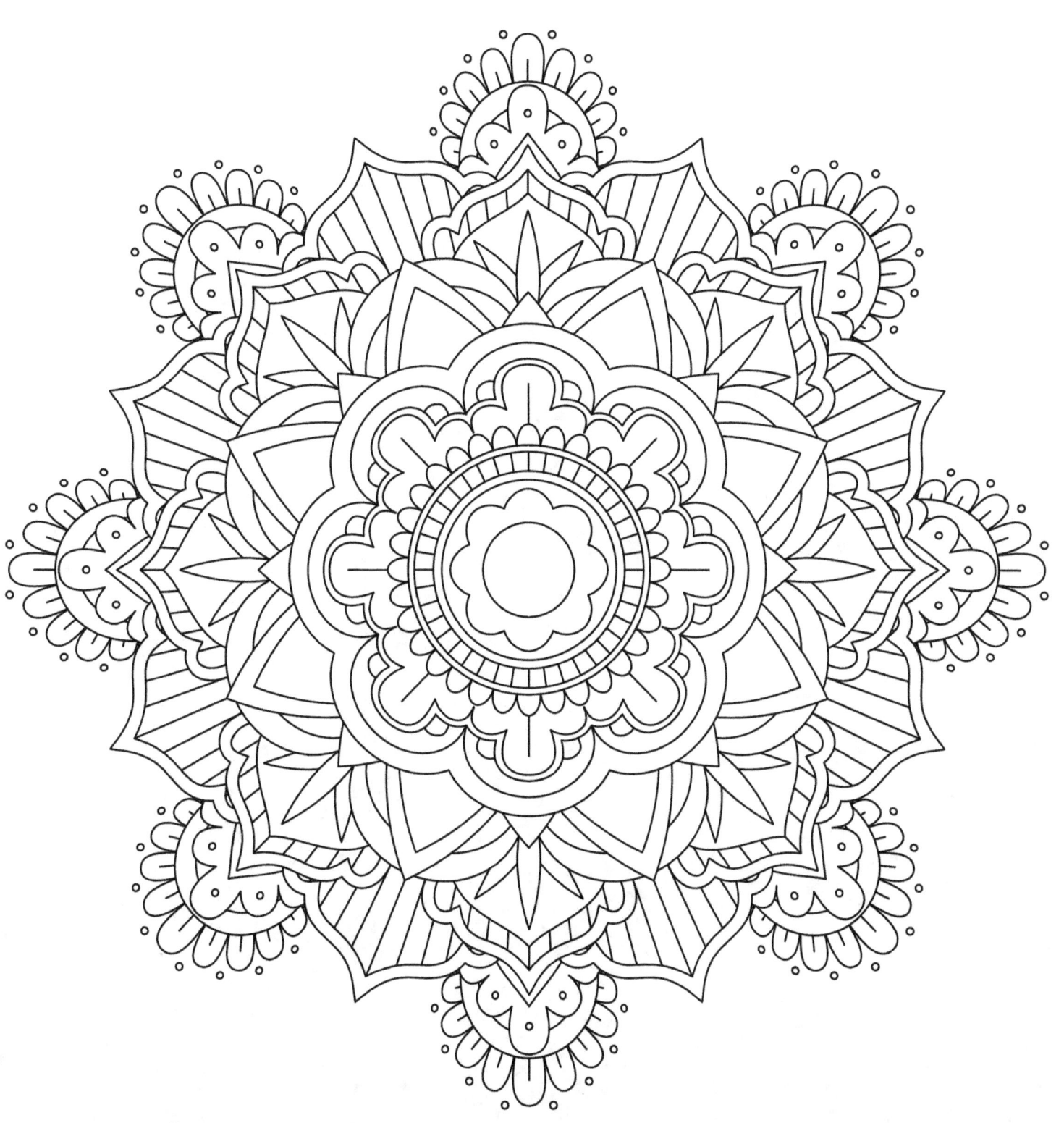

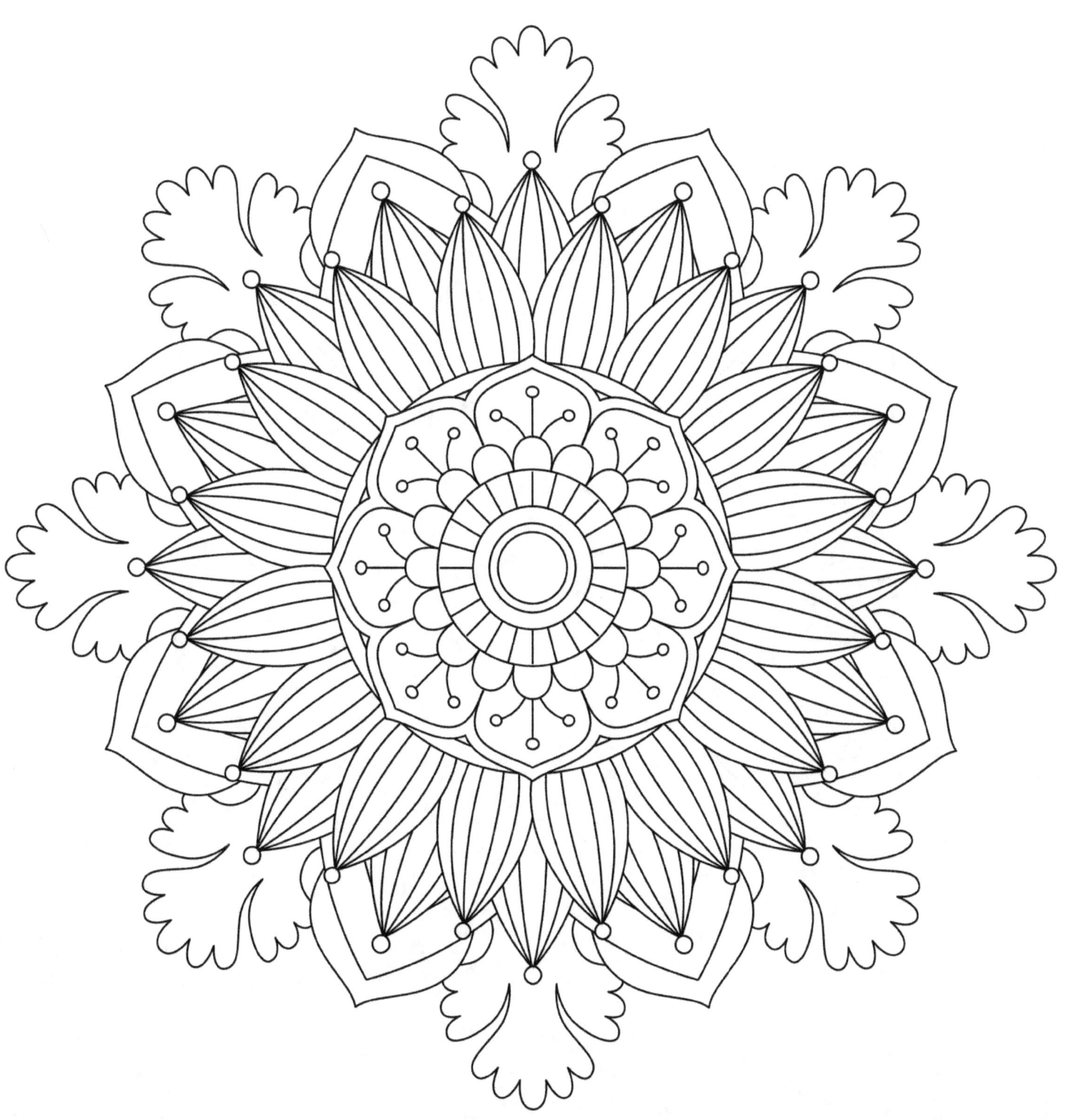

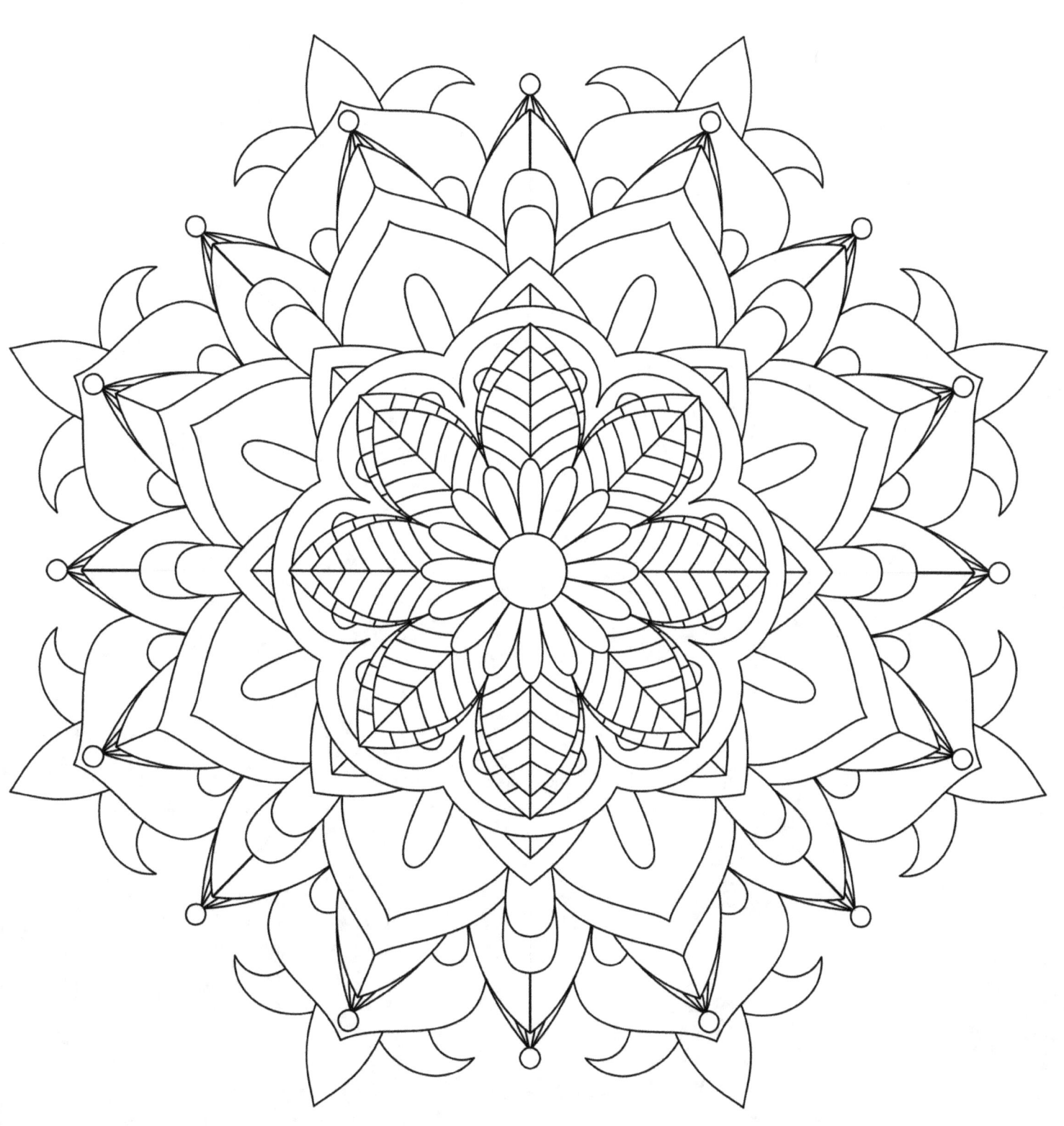

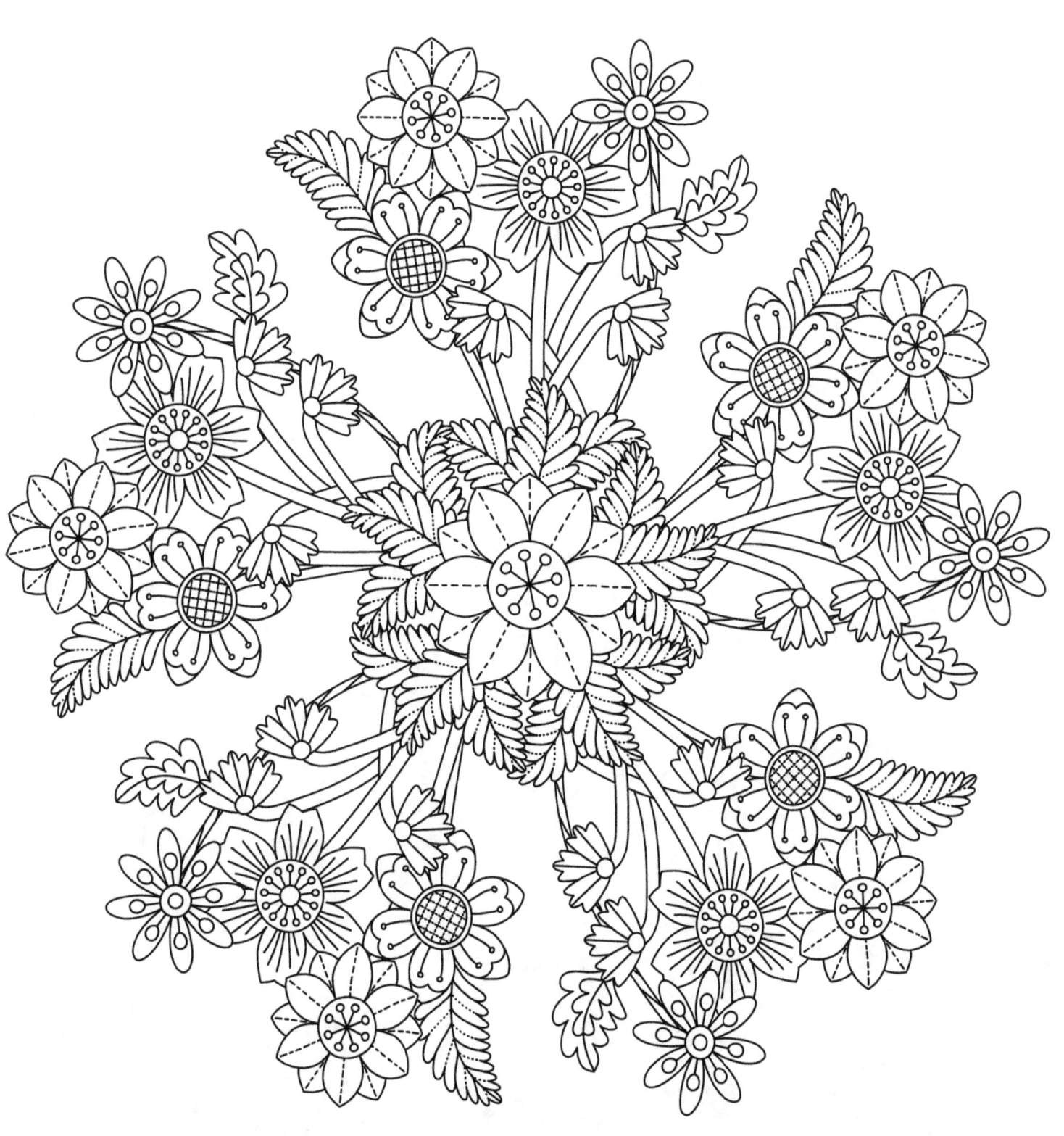

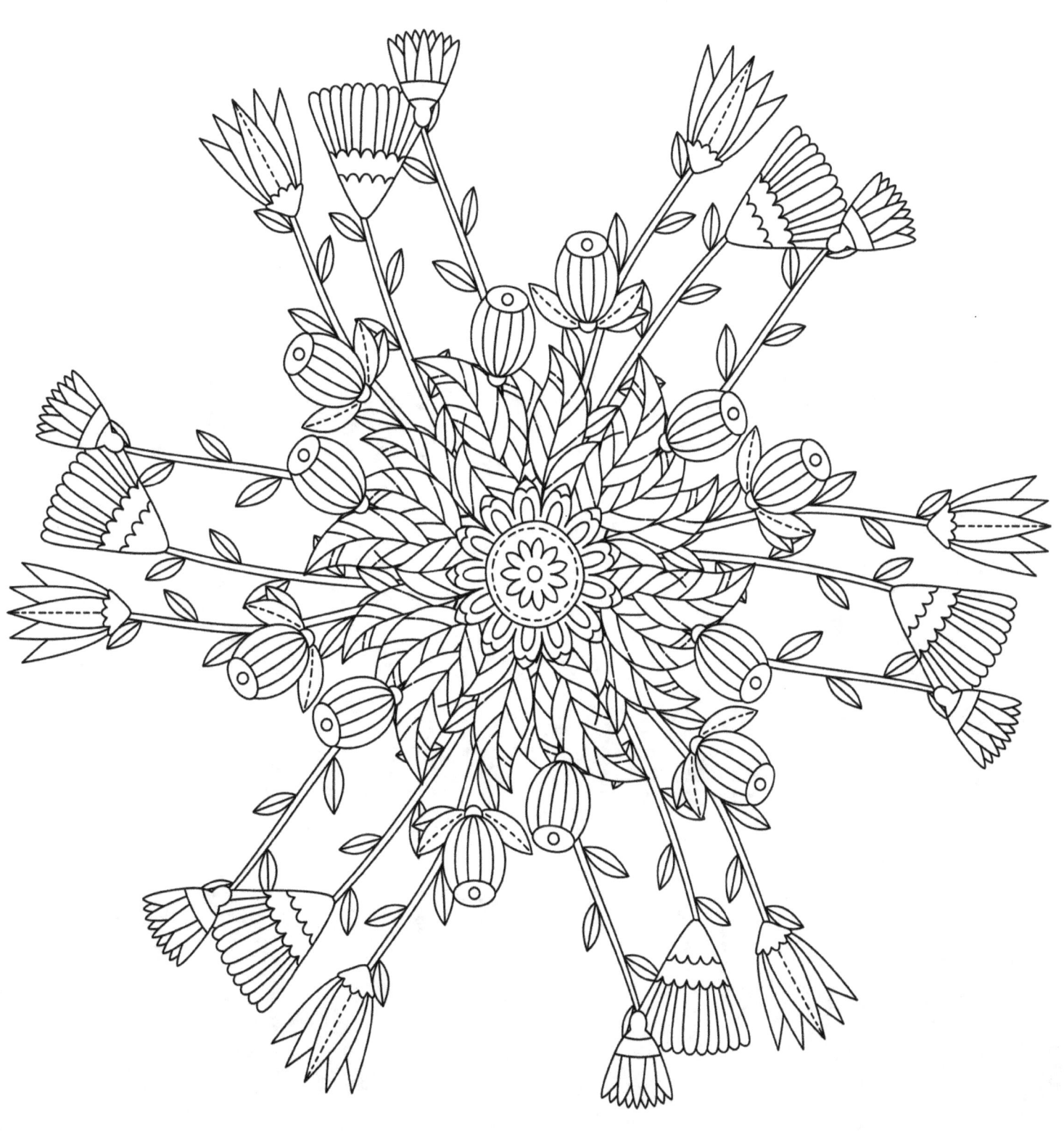

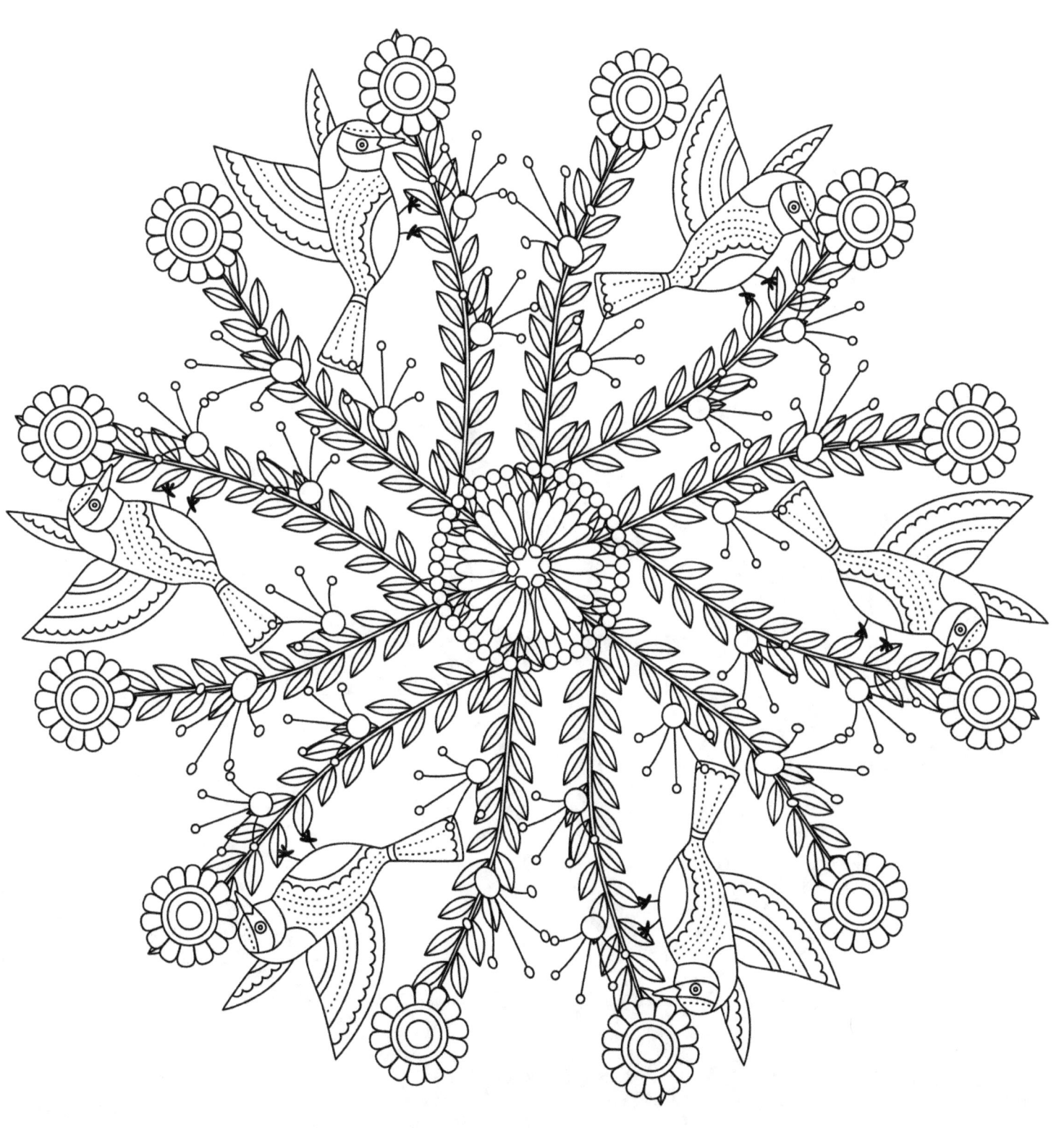

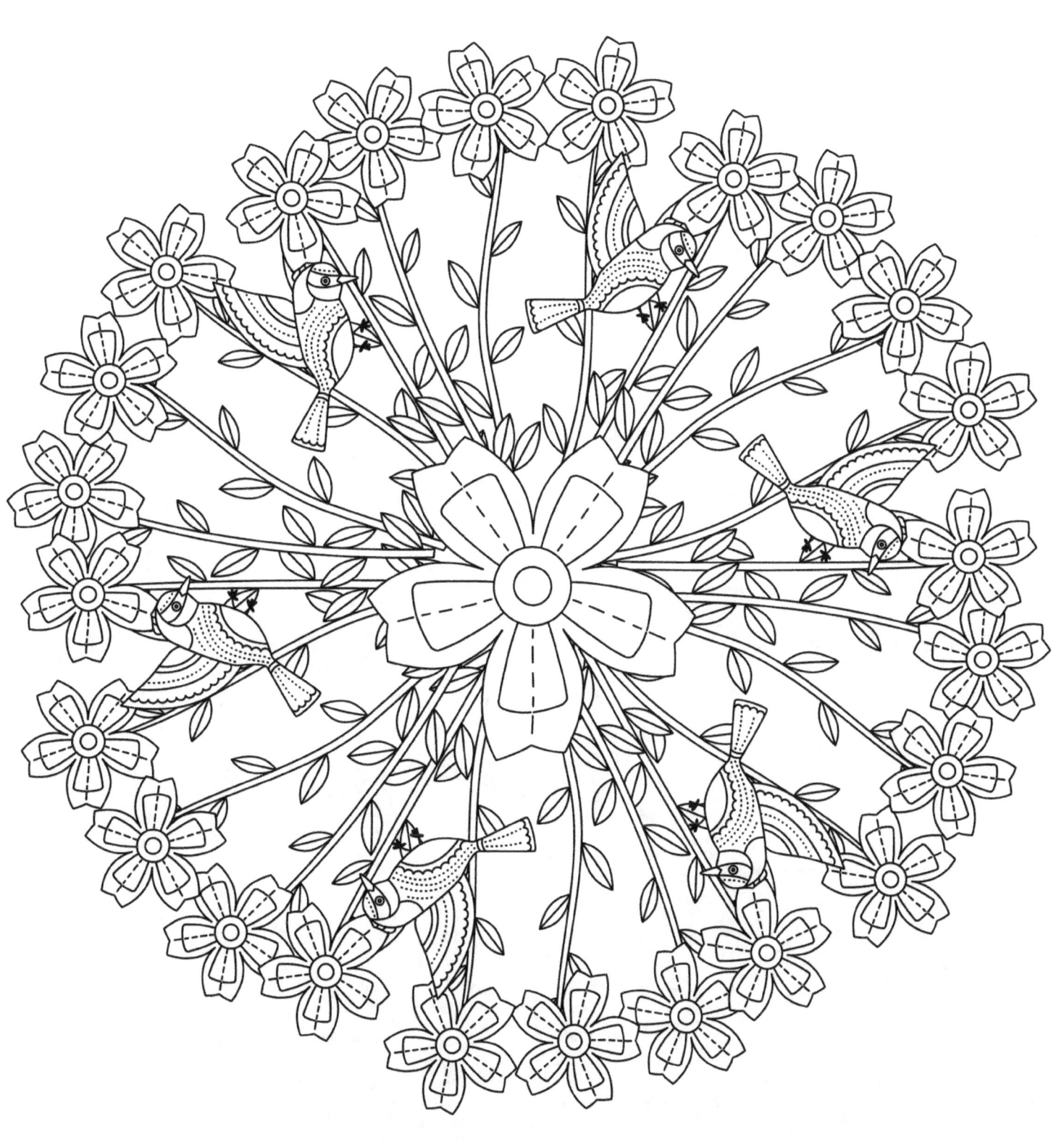

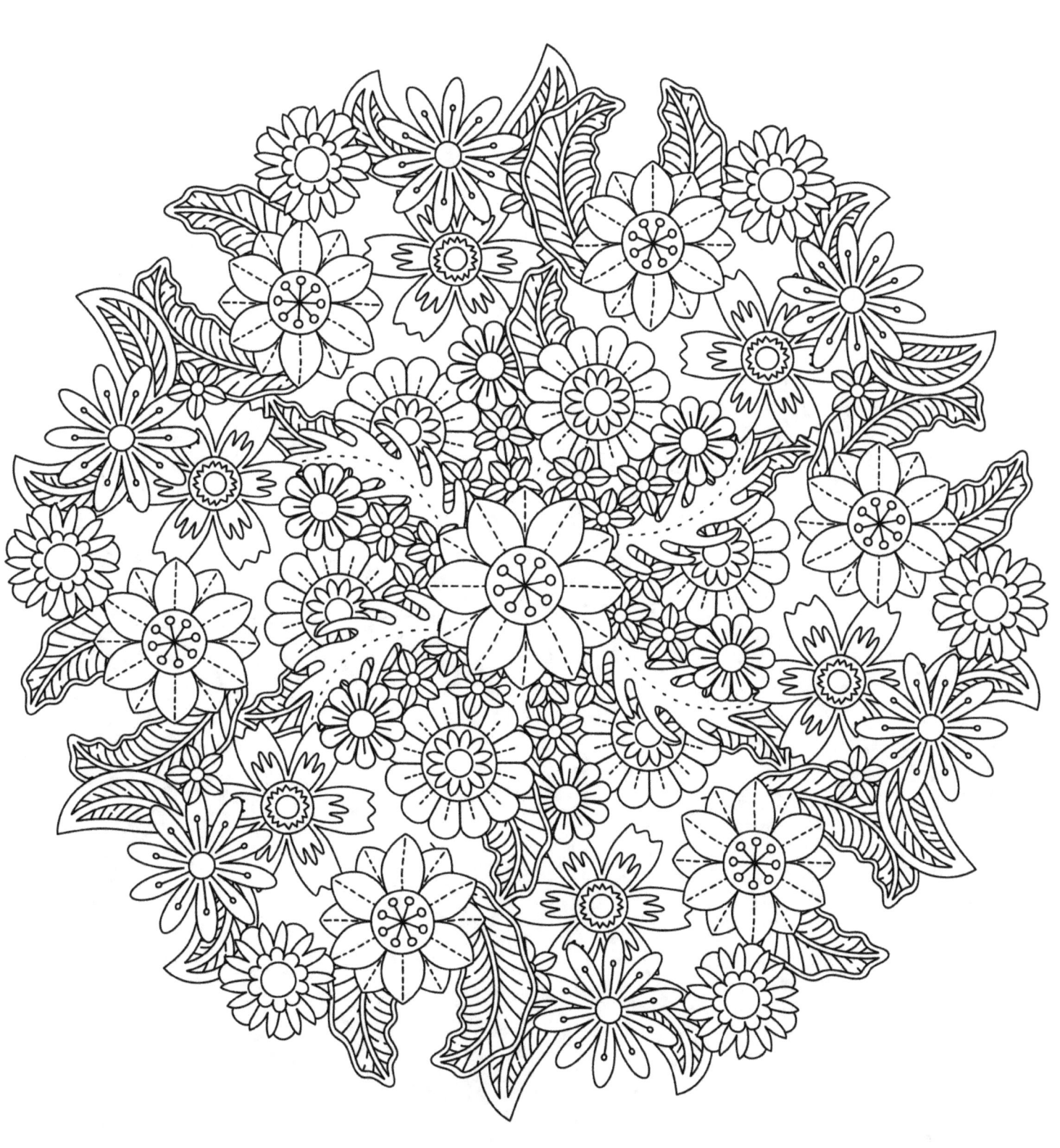

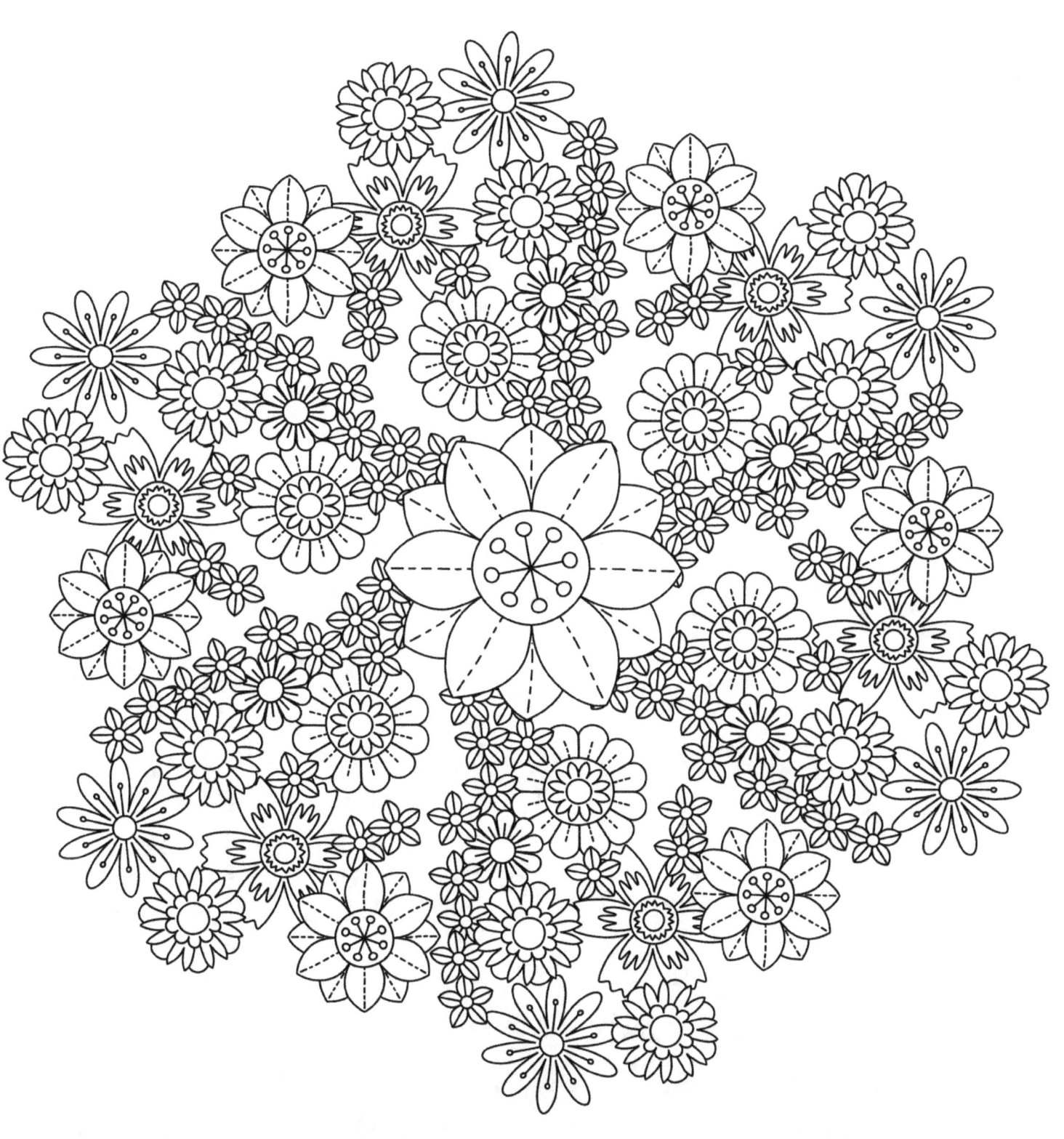

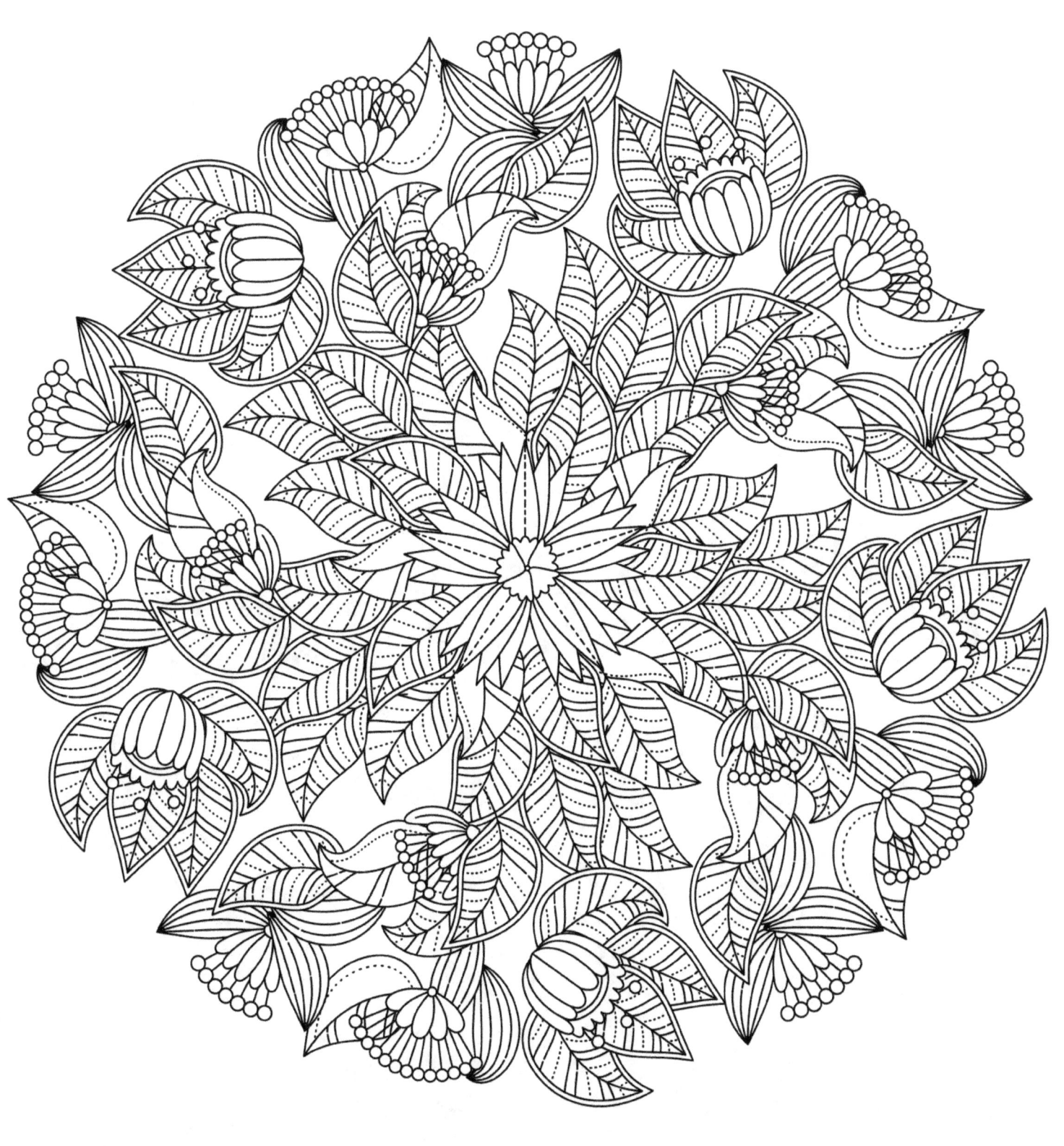

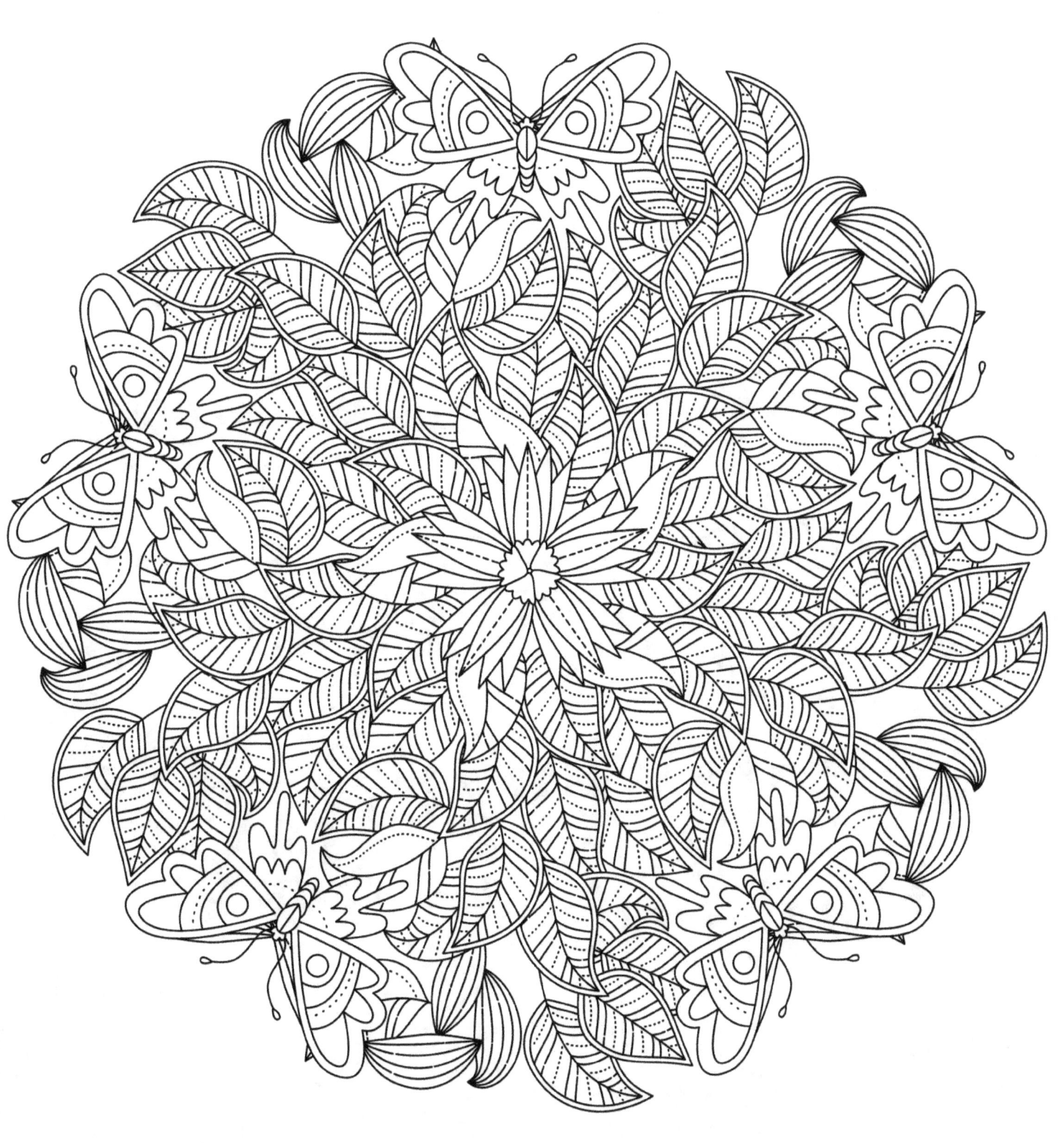